OUT
EAST
FROM ABOVE

SCHIFFER
PUBLISHING

4880 Lower Valley Road • Atglen, PA 19310

OUT EAST
FROM ABOVE

AN AERIAL VIEW OF THE SOUTH FORK

**LAINEY STEWART &
KAELEY MICHAELSON**

Foreword by Joey Wölffer,
Wölffer Estate Vineyard

Other Schiffer Books on Related Subjects:
Montauk 11954, Car Pelleteri, 978-0-7643-5605-6
Village Beaches: Pinhole Photography of East Hampton, New York,
 Photographs by Phillip Andrew Lehans, 978-0-7643-6583-6

Design by Lainey Stewart
Type set in Glowist/Mr. Eaves
ISBN: 978-0-7643-6899-8
ePub: 978-1-5073-0556-0
Printed in China

Published by Schiffer Publishing, Ltd
4880 Lower Valley Road
Atglen, PA 19310
Phone: (610) 593-1777; Fax: (610) 593-2002
Email: info@schifferbooks.com
Web: www.schifferbooks.com

For our complete selection of fine books on this and related subjects,
please visit our website at www.schifferbooks.com. You may also
write for a free catalog.

Schiffer Publishing's titles are available at special discounts for bulk
purchases for sales promotions or premiums. Special editions, in-
cluding personalized covers, corporate imprints, and excerpts, can
be created in large quantities for special needs. For more informa-
tion, contact the publisher.

For our children.
May you always find your way
to the ocean.

CONTENTS

As a native New Yorker, the Hamptons have always held a special place in my heart. From the magical light to the invigorating salt air and incredible landscapes, these surroundings shaped my childhood weekends spent on the fields and beaches of Sagaponack. We moved out east when I was nine. My life changed so beautifully when I moved out to the countryside, learning the value of hard work and knowing what it means to have a real sense of community.

In the wake of our father's passing in 2008, Marc and I made the decision to carry our father's legacy and take over Wölffer Estate Vineyard. Wölffer is more than just a winery; it's a sanctuary where friends and families gather to mark holidays and make beautiful memories while enjoying the beauty of the Hamptons. I am deeply proud to call this place my home, grateful to preserve its legacy and contribute to the enduring fabric of our community.

The Hamptons isn't just a picturesque getaway; it's where community thrives. Neighbors near and far come together to celebrate the seasons, support local businesses, and cherish the unique bond that living in this beautiful corner of the world fosters. It's a giant melting pot of people who understand that the true essence of the Hamptons lies in its spirit of togetherness and shared experiences. I am honored to be included in this book because Lainey and Kaeley also share the same appreciation for family and community building as I do.

JOEY WÖLFFER
Wölffer Estate Vineyard

PREFACE

WHY WE'RE HERE

I've never been great at meditating, but sometimes, when I close my eyes just right, I can still hear the distinct sound of my grandmother's feet shuffling down the boardwalk to the beach. She came down less toward the end of her life, but I choose to remember the early days. As my memory unfolds, that sound illuminates a familiar image, and soon I can see the view from above. It's a special stretch of earth that brings the ocean to beachgoers in Amagansett. There is an old boardwalk made of weathered wooden planks framed by whispers of beach grass that somehow always seem to be the perfect height. The dunes hug the stretch like rolling hills, and the sandpipers flutter about. As kids, my sister, Lainey, and I raced down that stretch hundreds of times every summer, and for a long time it felt like magic the way the boardwalk connected us to the beach. Now, when I'm transported here, in my attempted meditation, I'm in awe and

thankful. Thankful that I can still see my Grandma Vel in my mind, thankful that I can go back to this familiar place in real life, and thankful that it still exists just the way I remember it. In a world where so many things are quickly changing, it is comforting to have one of your favorite childhood places preserved. To me, that boardwalk is a bridge to some of the most beautiful moments of my family's history together. Lainey and I grew up on that beach with our parents, our grandmother, and many family members and friends along the way. We both brought our husbands there to capture wedding pictures, and now we take our children. For the last thirty-something years, my parents made the beaches in Amagansett and Montauk a summer refuge and then a home. This is why my sister and I have always wanted to capture it and share it with the world.

—Kaeley Michaelson

IN A WORLD WHERE SO MANY THINGS ARE QUICKLY CHANGING, IT'S COMFORTING TO HAVE YOUR FAVORITE CHILDHOOD PLACE PRESERVED.

ACKNOWLEDGMENTS

To our parents, Nikki and Daniel Dubinsky, for showing us life through these incredible places and making our favorite place on earth our home. We are who we are today because of your unconditional love, support, and guidance. Thank you for creating opportunities for us to explore, learn, and grow. It is because of you that our core childhood memories are rooted here (and with Van Morrison's *Days Like This* album playing in the background). Thank you for teaching us about the beauty and history of this land and sharing your stories with us. Thank you for dedicating your lives to ours and cultivating a family bond we can only hope to create with our children. We are eternally grateful to have you as our parents.

To our grandmother, Velma Dubinsky. Thank you for the countless childhood memories at Windward Shores and beyond. We feel closest to you walking down the boardwalk and hearing the shuffle of playing cards against the table on a warm summer evening. Thank you for imparting your wisdom and work ethic to us. We will never forget flash cards on the beach and you checking in on our summer reading lists. Your courageous spirit and passion for life remain inspiring to us. Thank you for challenging us, caring for us with such grace and love, and teaching us that sisters are special. We will continue to keep your soul and stories alive for the next generation.

To our husbands, Dan and Doug, thank you for understanding us, loving us, and supporting us. Thank you for recognizing that our relationship as sisters is an indescribable one—one that we sometimes have a hard time putting into words. Thank you for knowing what we need and celebrating who we are individually and together. Thank you for not only supporting, but also encouraging the early mornings, late nights and impromptu photo shoots. There are days we can't believe we found you and that, somehow, the universe knew exactly what we needed.

To every business featured, thank you for existing and sharing your pieces of the world with us. From families, founders, and owners to marketing directors and consultants, your collaboration over the years is tremendous. We appreciate

your support and contributions to this book. You've helped make our dreams a reality, and we feel privileged to bring your stories to life. A special thanks to Joey Wölffer and her team for recognizing our passion for these places and helping to honor the experiences and community building they create. Also, a big thank you to Ryan Garber for helping to get our images over the finish line.

To Pete Schiffer, thank you for believing in us and our book proposal. Since our first meeting, we knew immediately that you understood the importance of family and the root of our passion. To our editor, Ann Charles, thank you for your guidance, patience, and willingness to answer every question no matter how big or small. To everyone at Schiffer Publishing who leaned in to provide their expertise and help bring our vision to life, we thank you.

To our dear friends near and far who have also been on this journey with us, you know who you are! Thank you for providing input and another set of eyes. Lainey and I are so lucky to have a village behind us and we truly appreciate our mini focus group of fellow moms and friends who are like family, cheering us on.

Most importantly, this book is dedicated to our children. Each day, we have the privilege of experiencing life through your eyes and feel so lucky to be your moms. The thought of being able to capture and preserve this for you motivated us to accomplish our goal together. You light up our lives and keep us present. Henry, I was pregnant with you when Auntie Lainey started collecting the first drone shots. We decided that writing alongside her photos would be a great maternity leave project for me. It's comical because as I make final edits to this dedication, you are three years old, and, Harold, my sweet baby boy, you have somehow already turned one. Madison, your mom found out she was pregnant with you around the time we had a first draft outline of the layout. She is a visionary. She is the driving force behind every page, every shot, and every detail. She is a creative genius, and I will forever be in awe of her. I'm already proud to be your aunt because I know you'll have her bravery, tenacity, and ambition. You all are truly the wind in our sails. We love you.

How our bond as sisters, love for Long Island,
and Lainey's side hustle became an aerial view of the South Fork

For as long as I can remember, Lainey and I have wanted to work together. I think we felt like it would be the closest thing we could get to reliving the magic of our childhood. The nineties: a time when we were inseparable, the world was simpler, and we were just discovering how our talents are very different but equally complementary. We've always known how lucky we are to have the type of relationship we do and coming together as a creative (Lainey) and closeted writer (me) during the most significant transition of our life (motherhood) really does feel like the greatest achievement of our sisterhood and maybe even our lives *so far*.

Throughout this process, we've grown, evolved, and enjoyed spending more time fusing our strengths together. I've always admired Lainey and still look up to her, my incredibly talented little sister. Her eye for design and photography stands out, and I always knew her photography should be on display for more people to enjoy. During the COVID pandemic, Lainey decided that elevating her photography repertoire by getting her drone license would be a simple side hobby. If you know Lainey, this is not surprising. Naturally, she knocked it out of the park and, during a dark and uncertain time, found new light through another lens. We knew she was onto something special when we were able to experience some of our favorite places *from above*.

Ten Anchors became the first home for some of these photos. Launched in 2019, the brand was created by Lainey as a home for her photography, apparel and accessory designs, all of which take coastal inspiration. She set out to promote happiness and community through intentional collaborations with the likes of Serena & Lily in Wainscott and Hildreth's in Southampton.

These partnerships helped jump-start visibility into Lainey's artwork, finding them in homes, on local business walls, and now, coffee tables.

We're originally from Connecticut but spent every summer in Amagansett and Montauk, lucky enough to explore surrounding spots on the South Fork. But it really all started with our mom. She used to visit her Uncle Johnny and Aunt Helen at their East Hampton home every summer in the seventies. With years of great stories, she introduced my father to the area and the rest is history. Our parents bought land in Amagansett in the nineties, and while it would be years before they could build anything, we always felt like visiting was coming home.

Our family moved to the North Fork of Long Island in 2001, a pivotal time in our lives and the world. As Lainey finished elementary school and I started high

school, we became more immersed in everything that both forks of Long Island have to offer. (We hope to someday publish another book to focus on the North Fork *from above!*) It was during that era of our upbringing that my parents finally made Amagansett their home. Those transitions at a young age reinforced our bond as sisters and cultivated our knowledge, shared experiences, and appreciation for the East End.

Over the years, extended family, friends and then colleagues started asking us for advice on how to make the most of trips "out east." Somewhere along the way, we noticed we were doling out recommendations like bloggers via text, random Word docs, coffee or cocktails, and then social media. Our passion and love for this area have been there all along, so we decided to take what we had been recommending and make something more official of it. And so, *Out East from Above* was born.

Drawing on our journeys and the inspiration of the East End's beauty, we set out to showcase our favorite places to stay, things to do, eateries to try, and places to explore. Of course, not every one of our favorites made it in here, but you can think of this as a short list. We have our parents and our grandmother to thank for showing us the magic of Montauk, and, after decades experiencing it, we've captured both historic institutions and newer locations. We initially planned to focus on Montauk exclusively but quickly realized it would be impossible not to include a few other gems from the South Fork of Long Island as well.

In researching further for this book, we started to reconnect with business owners we'd met over the years and built new relationships too. This is something Lainey is also passionate about doing in her corporate work at Square, identifying connections with a variety of business owners who have a story to tell. Learning more about the heritage of these places and the families behind them reminded me of why, in high school, I wanted to become a journalist. Despite

studying communications and journalism, my passion became something of a missed calling. I have no regrets, but I did thoroughly enjoy that stage of my life under Mr. Roslak at Mattituck High School and Professors Knobel and Phelan at Fordham University. If nothing else, I'm proud to say I was able to tap in on some of those lessons here. I am honored for the opportunity to ask questions and hear stories from the people behind these wonderful places.

There are a few other voices you'll hear throughout the book as well. In stitching together the photography with our anecdotes, local history, and fun facts, we thought about adding another element to our storytelling. Interspersed throughout the book are poignant quotes from the likes of Andy Warhol, Ina Garten, and Edward Albee, all of whom have ties to the East End. This area of the world has inspired generations of famous creatives whose legacy lives on in the fabric of the Hamptons culture. Our goal was to publish a curated visual tour of the South Fork providing a unique window into the heart and soul of Montauk and beyond. We hope you stay awhile and get lost with us in one of the greatest places and communities to experience no matter the season.

STAY AWHILE

By the time you get out here, you won't want to leave. Well, at least that's how we feel! Since time is of the essence, we highly recommend making the most of it. Pack your bags and imagine settling into one of these scenic spots. While we haven't personally stayed at all of them, we've visited each one via friends and family visiting from out of town. These are the gems that will make you want to drop your bags, turn off your notifications, and stay awhile. In no particular order . . .

Hero Beach Club
Shou Sugi Ban House
Windward Shores
Marram

Baron's Cove
Gurney's
Solé East
The Crow's Nest

HERO BEACH CLUB

One of our favorite moments driving into Montauk is when you make your way over the hill of Montauk Highway and coast right into town. The iconic smiley face–adorned Hero Beach Club is always there to greet us in that moment. For years, Lainey and I have said it's such a warm reminder of how welcoming this little slice of heaven really is. The cheerful vibes of Hero Beach Club aren't the only reason we love this place. It's also the perfect location for Montauk goers looking to stay in the center of it all. From the ocean to the pool, to the great spots in town, there is plenty within strolling distance.

Entering the gates of Shou Sugi Ban House in Water Mill is met with an immediate sense of Zen. An 8-ton Buddha statue welcomes guests upon arrival and symbolizes the property's wabi-sabi designed architecture and tranquil grounds. Shou Sugi Ban House is a year-round luxury wellness destination featuring serene accommodations, an award-winning spa, and healing treatments such as yoga, breathwork, and nutrition classes. We love strolling the pebbled pathways to enjoy the water fountains and dining orchard. Let the feeling of wellness wash over you and embrace the calming energy of Shou Sugi Ban House.

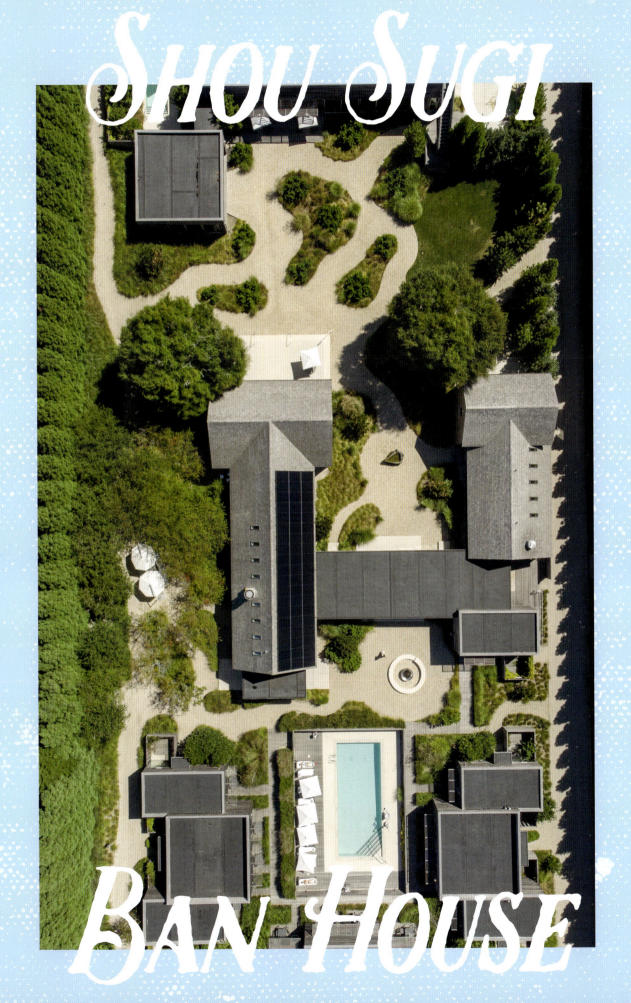

Shou Sugi

Ban House

WINDWARD

SHORES

Talk about a time capsule. To us, Windward Shores was our second home growing up, but today we recommend it to anyone seeking an oceanfront family getaway. Situated right on the Napeague stretch, Windward Shores is the perfect halfway point between the center of Montauk Village and Amagansett Square. East End lovers have direct access to the soft sandy beaches of Napeague, with a seasonal heated pool, and condo-style accommodations featuring kitchenettes that make extended stays a breeze.

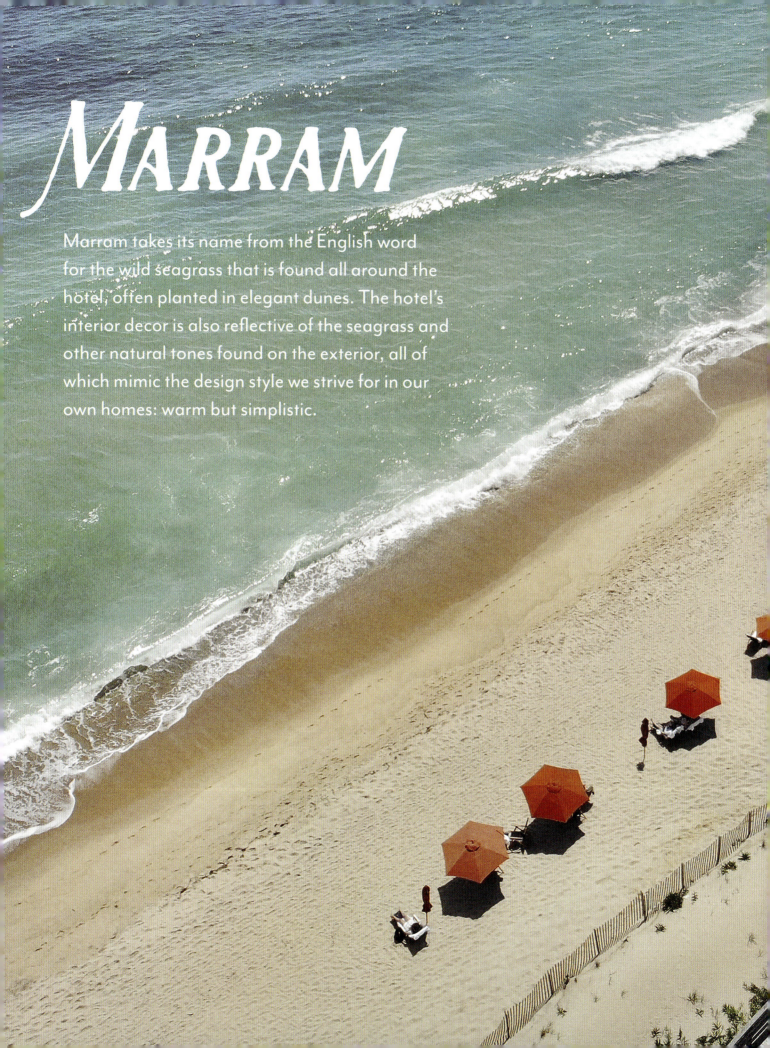

MARRAM

Marram takes its name from the English word for the wild seagrass that is found all around the hotel, often planted in elegant dunes. The hotel's interior decor is also reflective of the seagrass and other natural tones found on the exterior, all of which mimic the design style we strive for in our own homes: warm but simplistic.

"

*You're alive only once,
as far as we know, and
what could be worse than
getting to the end of your
life and realizing you
hadn't lived it?*

"

EDWARD ALBEE

Baron's Cove is the epitome of nautical charm. Nestled in the village of Sag Harbor, this relaxing getaway destination is inviting for out-of-towners looking to settle in Sag or local diners seeking an all-American restaurant. The property offers lovely amenities to hotel guests but also serves as a great midday pit stop to take in the views of boaters passing by. We love how Baron's Cove mixes historical opulence with modern touches to create a unique ambience. All year long, Baron's Cove offers special holiday menus and partnerships with local businesses such as the Bay Street Theater and Wölffer Estate.

BARON'S COVE

Gone to... GURNEY'S

Capturing Gurney's from above seemed like the only way to do justice to the views, the beach, and the architecture. They say you can live your best life while at Gurney's, and they aren't wrong! From sunset cocktails by the fire pit, to the unforgettable homemade spaghetti at Scarpetta Beach, Gurney's has it all.

In the height of the season, we prefer securing a spot at The Beach Club and indulging in a signature coconut-and-tequila cocktail. But no matter the season, our favorite thing to do is splurge on a wellness day at the soothing Seawater Spa.

Solé East is the perfect oasis off the beaten path. Between the bamboo-covered walkways and tranquil poolside lounge, you'll find bungalow-style hotel rooms set in a Montauk landmark American Tudor building. Solé East is just a quick walk to the ocean and not far from the center of town. The property features an open-air restaurant and bar and an outdoor fire pit. Its grounds are also perfect for tying the knot. Solé East will forever have a special place in my heart. My husband and I exchanged handwritten vows under "the wedding tree" in their backyard garden, and now, years later, we take our children to run about on the lush grounds.

SOLÉ EAST

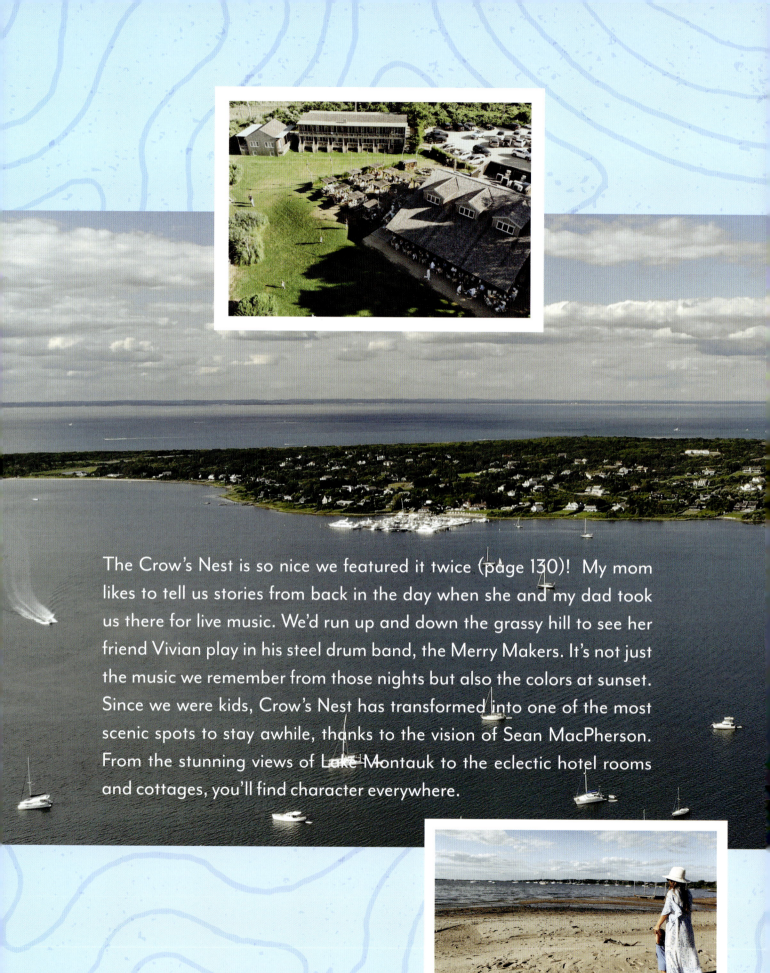

The Crow's Nest is so nice we featured it twice (page 130)! My mom likes to tell us stories from back in the day when she and my dad took us there for live music. We'd run up and down the grassy hill to see her friend Vivian play in his steel drum band, the Merry Makers. It's not just the music we remember from those nights but also the colors at sunset. Since we were kids, Crow's Nest has transformed into one of the most scenic spots to stay awhile, thanks to the vision of Sean MacPherson. From the stunning views of Lake Montauk to the eclectic hotel rooms and cottages, you'll find character everywhere.

THE CROW'S NEST

GET LOST

Out east, enjoying the scenery itself is a pretty perfect way to spend an afternoon. But beyond the beaches, you'll find a wide range of things to do and places to enjoy. From iconic landmarks to lesser-known nature walks, we focused on capturing a few must-see destinations sprinkled with our favorite hidden gems that have become . . . not so hidden.

The Art Barge
Shadmoor Cliff Walk
Montauk Point Lighthouse
Peconic Water Sports
Gosman's Dock
Wölffer Estate
Sag Harbor Florist

Puff & Putt
Montauk Downs
Montauk Skatepark
Walking Dunes
Amber Waves Farm
Montauk Brewing Company

THE ART BARGE

For those of you seeking a bit of history and culture, look no further than the Victor D'Amico Institute of Art, comprising the Art Barge and the Mabel & Victor D'Amico Studio and Archive.

Beached in the dunes of Napeague Harbor, the Art Barge emerged in March 1960, created from a retired World War II Navy barge by the progressive-era artists and educators Mabel and Victor D'Amico. My mom introduced us to the Art Barge when we were in elementary school. It was a rainy August in the early nineties, and she was committed to finding us new ways to experience Napeague. She signed us up for classes, and it was there where my sister developed an early talent for art and where I pretended to emulate my father's watercolor paintings. Whether you color in the lines or not, the Art Barge is an inspiring place where you can see both Napeague Harbor and the Atlantic Ocean. Take a class or make a donation to preserve this historic landmark.

"

Up next, book a tour for the Mabel & Victor D'Amico Studio and Archive to learn about the two incredible artists and educators who brought art to The End. Before he and his wife made their way out east, Victor was the founding director of education at the Museum of Modern Art and had a vision for sharing his approach through summer painting lessons.

ART IS A HUMAN NECESSITY AND SHOULD BE PART OF EVERYONE'S LIFE EXPERIENCE.

He believed that "the arts are a humanizing force and that their major function is to vitalize living," and his wife, Mabel Birckhead D'Amico, shared in this passion, devoting her life to modern art education. Together they inspired generations through their teachings at the Art Barge, and now their dreams live on through their legacy in Lazy Point.

"

VICTOR D'AMICO

This photo, of this walk, is one of the reasons *Out East from Above* was born. When Lainey first showed it to me, I was breathless. The cliff walk is a 2.5-mile loop along the bluffs of Shadmoor State Park, running from the end of Montauk's town beach to Ditch Plains. This hike has become a family tradition at Thanksgiving when our cousins and aunt come to visit, and it is always invigorating to walk it together. We love this hike best off-season, when you can feel the whisper of winter approaching or even see the cliffside snowcapped. In researching for this book, we learned more about Shadmoor's impressive bluffs.

SHADMOOR
Cliff Walk

The wavelike ridges you see are something geologists call "hoodoos," the unique formation of rock, sand, and clay patterns from extreme erosion. Whether you're into birding or just looking for some fresh air and exercise, Shadmoor's Cliff Walk will leave you feeling the salt air for days to come.

THE MOST SCENIC CLIFF WALK AT THE END - 900 MONTAUK HIGHWAY

> **Standing cliffside
> I realize how tiny we must
> look from above.**

LAINEY

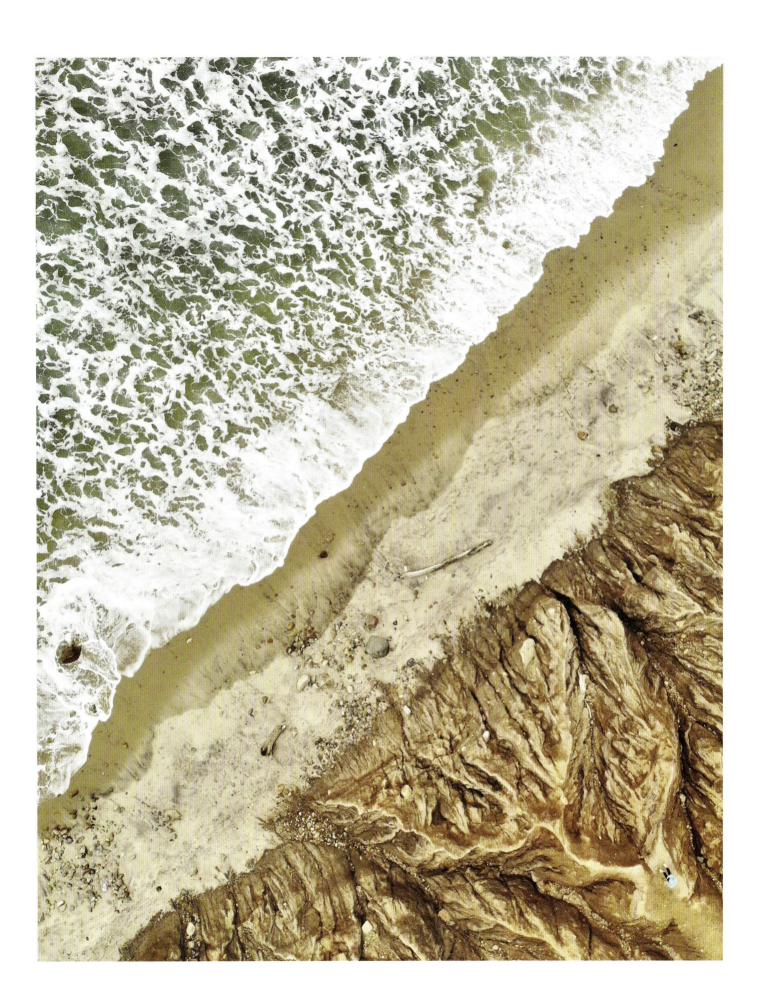

Montauk Point

A trip out east isn't complete without a visit to Montauk. Often referred to as The End, for marking the easternmost point of Long Island and New York state, it is symbolized by the Montauk Point Lighthouse. Take a drive or bike ride to this historical landmark where you'll be blown away by the beautifully restored beacon of light on Long Island.

Originally commissioned by George Washington in 1792, it is the fourth-oldest lighthouse in the nation and was the first ever built in New York. We spoke with Mia Certic, executive director of the Montauk Historical Society, to learn more about how the nonprofit organization owns the lighthouse and is responsible for maintaining its magic in Montauk. The lighthouse is an incredible destination for visitors and families and has a terrific museum and interactive virtual aquarium. We love climbing to the top of the lighthouse for the 360-degree views!

LIGHTHOUSE

Get to
THE POINT

PECONIC

One of the best ways to experience the South Fork is by boat, and our friends at Peconic Water Sports know exactly how to deliver. With an extensive menu of charter options, water sport activities, and all the gear to make it possible, they handle everything to curate the most memorable seaside experience. Our idea of a perfect day is hopping on board at Three Mile Harbor and wake surfing through the pristine waters surrounding Shelter Island. With six pickup locations, we encourage you to ditch the traffic and get salty out at sea!

WATER SPORTS

Peconic Boat Club

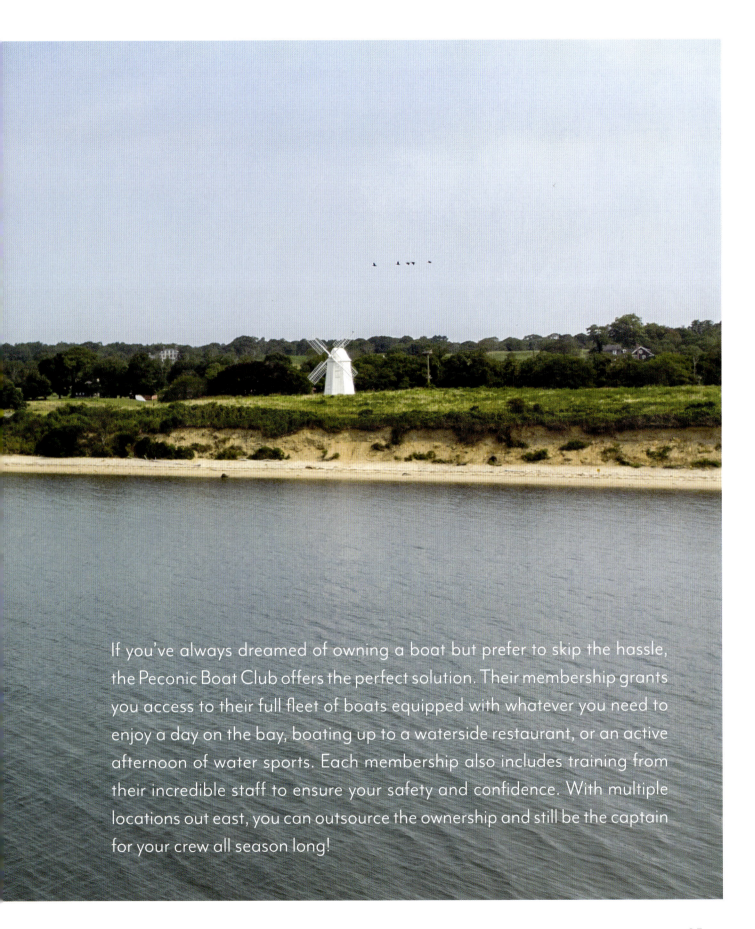

If you've always dreamed of owning a boat but prefer to skip the hassle, the Peconic Boat Club offers the perfect solution. Their membership grants you access to their full fleet of boats equipped with whatever you need to enjoy a day on the bay, boating up to a waterside restaurant, or an active afternoon of water sports. Each membership also includes training from their incredible staff to ensure your safety and confidence. With multiple locations out east, you can outsource the ownership and still be the captain for your crew all season long!

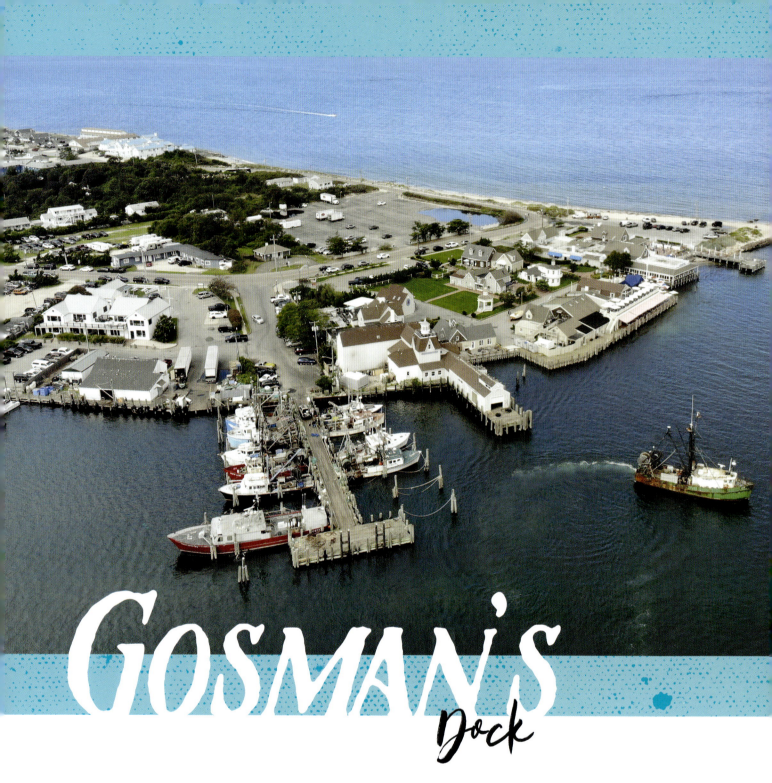

GOSMAN'S Dock

Gosman's has certainly grown over the years, but we still remember going to the docks as kids just to watch the fishing boats come in. Now, locals and visitors alike can make the area overlooking Montauk Harbor a multistop destination. From the little retail shops clustered between Gosman's trifecta of restaurants, to their ice cream shop and gourmet market, Gosman's is a great way to spend the day!

WÖLFFER

ESTATE

Wölffer Estate is our pick off the South Fork grapevines, and we think you'll agree too. Located in Sagaponack, Wölffer is a family-owned vineyard most known for its beautifully bottled rosé, convenient Wine Stand, and live music. What people may not realize is that Wölffer started making rosé back in the nineties, before it took over reality shows and social media. Now, Wölffer's Summer in a Bottle is the cool bohemian queen of rosé and synonymous with its namesake season. We fell in love with Summer in a Bottle at first sip and sight!

SUMMER SUMMER SUMMER SUMMER SUMMER

SUMMER IN

SUMMER

A BOTTLE

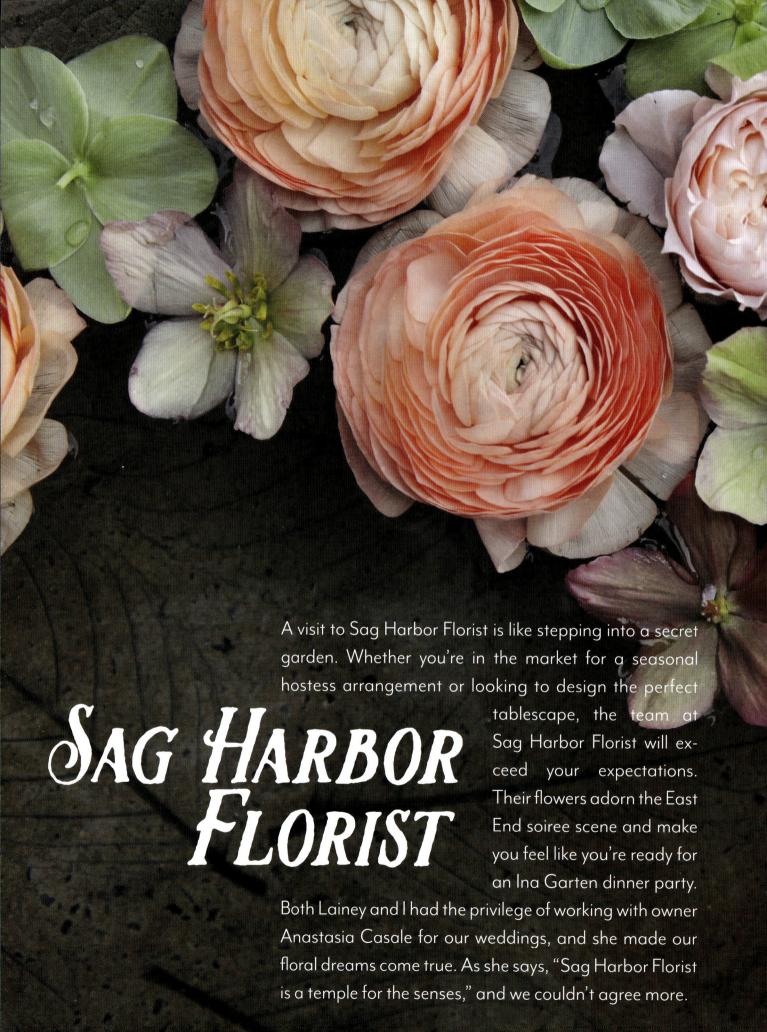

SAG HARBOR FLORIST

A visit to Sag Harbor Florist is like stepping into a secret garden. Whether you're in the market for a seasonal hostess arrangement or looking to design the perfect tablescape, the team at Sag Harbor Florist will exceed your expectations. Their flowers adorn the East End soiree scene and make you feel like you're ready for an Ina Garten dinner party. Both Lainey and I had the privilege of working with owner Anastasia Casale for our weddings, and she made our floral dreams come true. As she says, "Sag Harbor Florist is a temple for the senses," and we couldn't agree more.

> " **I always like to have flowers on the table. I think they make it look special.** "

INA GARTEN

PUFF & PUTT

Puff & Putt is a great activity for all ages. The vintage mini golf spot has incredible waterfront views and, to us, represents another nostalgic landmark. Since 1977, the family-owned and family-operated Puff & Putt has brought smiles and swings to Montauk. Each hole has a fun obstacle for the whole crew to enjoy. Puff & Putt also offers night golfing for those late-summer evenings, and Hobie Cat, paddleboard, and kayak rentals too! There really is something for everyone to enjoy. Pro tip: Walk to John's Drive-In afterward for ice cream. Mini golf winner pays the tab!

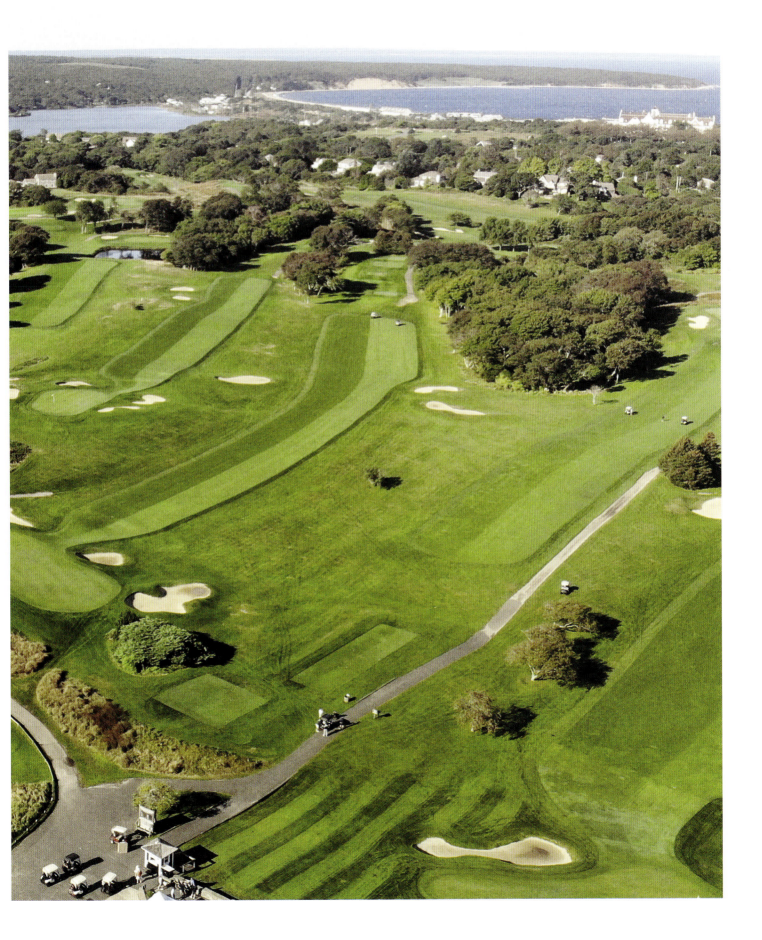

MONTAUK DOWNS

Did you know that Montauk Downs is one of the top-rated municipal courses in the country? Our dad used to take us to the range before we could even fit into real golf shoes. Those days, "closest to the pin" was just a Sunday morning competition on the putting green. For the record, he never let us win.

Today, the Downs is something of a portal to us. A link to our past and always one of our first recommendations to friends visiting from out of town. You don't need to be an avid golfer to appreciate the community that flocks to the fairways of Montauk. Just don't forget your NYS driver's license (IYKYK).

MONTAUK
SKATEPARK

The Montauk Skatepark is 20,000 square feet of wavelike custom concrete designed intentionally to support all levels of skating. The park reopened in 2022 after the community and the Town of East Hampton banded together for its impressive renovation. The original skatepark was designed in 1999 by Andy Kessler, a famous New York skateboarder who pioneered dedicated skateparks in the city and Long Island. Today, the skatepark continues to foster a graffiti-free community through donations and events such as Skate Day Fridays, where kids can connect with seasoned skateboarders through community skate sessions.

WALKING

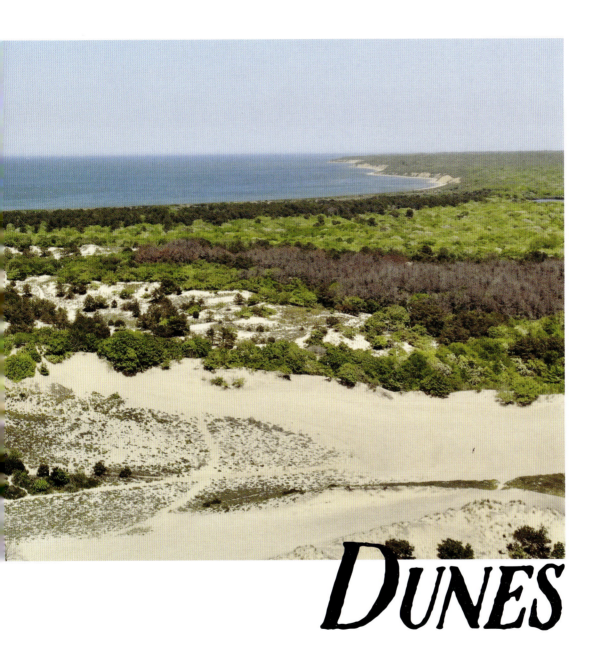

DUNES

For a different vantage point, look no further than the historic Walking Dunes. At the end of Napeague Harbor Road you'll find a trail to protected land and a piece of Amagansett's Nature Preserve. To maintain the unique dune ridges and local ecosystem of plants and animals, it is imperative that visitors remain on the trailed footpath. Once you've completed the Walking Dunes trail loop, you can enjoy a grand finale stroll along Iodine Beach.

AMBER WAVES

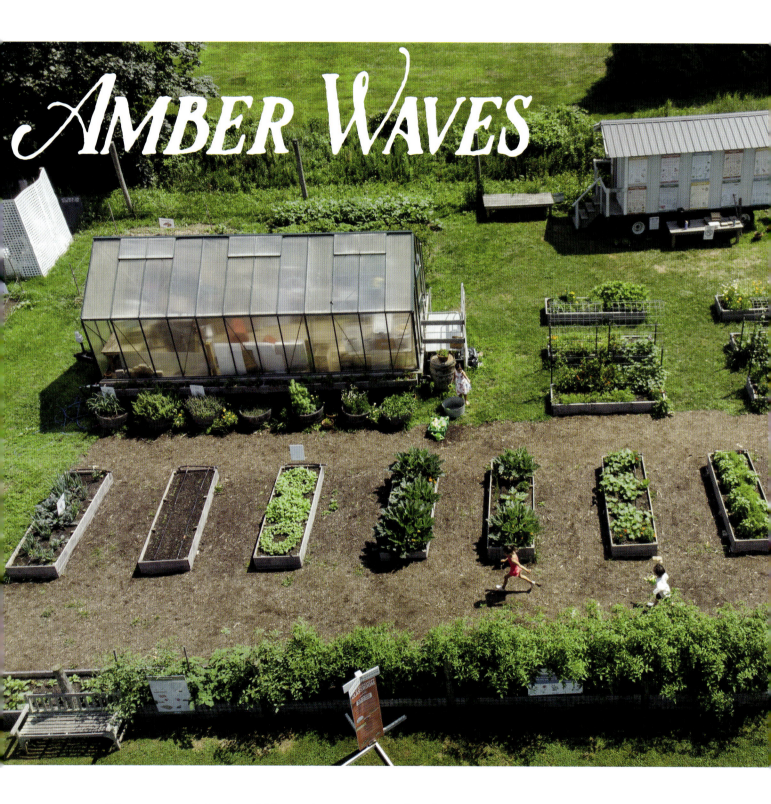

The story of Amber Waves began with the Amagansett Farmers Market, a place we often went with our parents on lazy weekend mornings in search of the perfect produce. Our family history is also rooted in agriculture, and we've always had a deep appreciation for the history of this oceanside farm.

FARM

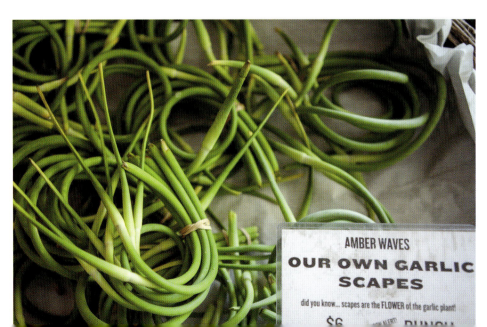

AMBER WAVES

OUR OWN GARLIC SCAPES

did you know... scapes are the FLOWER of the garlic plant!

Amber Waves was established in 2008 when a friendship was born between apprentices Amanda Merrow and Katie Baldwin. Their vision was to nurture the farm fields behind the market and cultivate a broader community. Under their leadership, Amber Waves has grown to nearly 30 acres across various fields in Amagansett and East Hampton, all of which benefit from the impact of the ocean's proximity to its soil and its involvement in the community.

Today, Amber Waves Farm is a nonprofit teaching farm devoted to stewardship and community building through four main programs. Their farming apprenticeship is dedicated to training the next generation of farmers. Children's education is provided through enrichment programs that focus on engaging kids in nature through hands-on discovery. Amber Waves' farming philosophy is also rooted in food security through their organized donations to the community. Their open-access atmosphere fosters farmers of all ages to explore and connect with neighbors and friends. Visit for the day and enjoy their incredible market and kitchen, which features straight-from-the-farm food options, or walk the property to take in the beauty of its being.

MONTAUK BREWING CO.

When the founders of Montauk Brewing Company opened the doors to the little red house in the center of town, we knew it'd be something special. Since the beginning, the tasting room felt like a missing piece to Montauk had been found. A place like this should absolutely have its own beer and the perfect patio setup to bring people together.

QUALITY EATS

We could dedicate an entire book to East End restaurants, but we'll save that for another project. Instead, we're featuring some of our favorites by showing you why they made it. "Quality Eats" isn't just about the food. It's also about the views and the atmosphere. Sit back and soak in a bird's-eye view of the most captivating bites, cocktails, and caffeine of the East End.

The Crow's Nest Montauk Bake Shoppe
Duryea's K Pasa
Inlet Seafood Sí Sí
Mavericks Goldberg's
Alimentari Beach Ditch Witch
Clam Bar Hooked
El Taco Bar Left Hand

The CROW'S NEST

Golden hour on Lake Montauk is as colorful as the dishes at The Crow's Nest restaurant, making it the perfect backdrop for diners and a destination in and of itself. The mezze platters and fresh fish pair perfectly with their vibrant cocktails. It's here that guests can enjoy incredible locally sourced ingredients in a cultural atmosphere. Whether you're dining alfresco or taking in the gypset decor, The Crow's Nest is a vibe to stay, sip, or dine. Don't forget to hit the beach bar before or after dinner; there, you'll find the perfect perch for guests seeking a lakeside cabana and a St. Tropez–meets–local–Montauk vibe.

DURYEA'S
Montauk

134

For our favorite place to wine and dine midday, look no further than Duryea's! This picturesque spot is set right on the water and is ideal for alfresco dining. The salty air is the perfect addition to Duryea's delicious menu. You can't go wrong with the seasonal oysters. Duryea's has evolved over the years, but the Lobster Deck is legendary. It's one of our favorite places to enjoy the best seafood, atmosphere, and rosé all day! Bonus: Peep the very end of the book for a photo you can only snap from the dock at Duryea's.

135

" Respect the ocean. Harvest the bounty. Feed the people. "

INLET SEAFOOD

INLET

Inlet Seafood is a standout for many reasons. Owned by six local fishermen, this treasure has a dock-to-dish approach to dining like no other. The restaurant's seafood is exclusively caught locally by a fleet of boats that call its 8-acre property home. We had the privilege of spending time with some of the local fishermen responsible for the daily catch. Capturing their process live represents all that Inlet Seafood stands for: *Respect the Ocean. Harvest the Bounty. Feed the People.* The stunning panoramic views of Block Island Sound are also the perfect accompaniment to some of our favorite dishes such as the lobster fra diavolo and Inlet's signature sushi rolls!

SEAFOOD

"From our boats

to your plates."

DOCK to DISH

MAVERICKS

One of Montauk's best restaurants reflects a match made in heaven, and we're not just talking about the surf and turf Mavericks is known for. Chef Jeremy Blutstein and Vanessa Price prove to be the perfect pairing at Mavericks.

Blutstein is an Amagansett native with experience at East End institutions such as Estia's, Crow's Nest, Surf Lodge, and Gurney's. His appreciation for East End farm-to-table food curation is intentional. The Mavericks menu is studded with local ingredients such as Montauk fluke, Amagansett fennel, Hudson Valley foie gras, and Sagaponack carrots—all to support the local community.

Price is a wine expert whose bold personality and desire to make wine accessible brought her to Mavericks. The wine list and cocktail menu stand out. We love the Mavericks Weekend Warrior (a.k.a. the perfect spicy marg) and never pass up an opportunity to sip a cocktail and take in the perfect sunset view off Fort Pond.

Alimentari Beach

For anyone seeking a little slice of Italy, be sure to check out our friends at Alimentari Beach. Another stop on the Montauk Village food tour, Alimentari offers guests dining in an authentic menu of gourmet pizzas and pastas. Or, if you're in the mood to cook something at home, pop into their market to procure fresh ingredients for your own kitchen!

CLAM BAR

"East of Amagansett, west of Montauk, on the Highway," Clam Bar is a family-owned and family-operated roadside restaurant that is a true sign of all things summer. The team at Clam Bar serves up the best lobster rolls in town with the perfect sides, summer cocktails, and other great local fare.

El TACO Bar

Introducing the **Passion En Fuego**,
one of our favorite craft cocktails curated by
El Taco Bar's managing partner,
Steven Carro:

2 oz. Teremana Blanco Tequila
1 oz. passionfruit puree
0.5 oz. dry Curaçao
0.5 oz. agave
0.75 oz. lime
4 sprays of atomized habanero bitters prior to
ice in glass, 2 sprays on top

Glass: circled etched
Rim: Tajin salt
Production: shaken, poured with ice
Garnish: dehydrated lime wheel, chili threads

MONTAUK
BAKE SHOPPE

They say breakfast is the most important meal of the day, and at a place like Montauk Bake Shoppe, you won't be disappointed. Located right in the heart of town, the Bake Shoppe is always bustling, serving up classic BECs and its famous cream- or jelly-filled croissants. Get up early to beat the lines in the summer, or swing by off-season for a special seasonal treat. Either way, this Montauk staple is a must-stop for cookies, cakes, and coffee.

MONTAUK
BAKE SHOPPE
Breads • Pastries • Cakes • Coffee • Cappuccino
631-668-2439
On The Plaza

When K Pasa debuted in Sag Harbor in 2019, we knew it would be a mainstay. We consider tacos and tequila to be dietary staples, and the team members at K Pasa are masters of a well-balanced meal. Chef Miguel Reyes Castillo shaped an all-day menu offering healthy breakfast tacos and quinoa bowls, alongside lunch and dinner options that marry his Mexican roots with a chill California vibe. Noteworthy dishes we can never get enough of: the croquettes and spicy tuna, Baja fish tacos, mole mushroom gratin tacos, and lamb birria. But the real leading lady is K Pasa's prickly pear margarita. It's no wonder that "K Pasa is about keeping the local summer vibe going all year round."

K PASA

Sí Sí brings more "yes yes" to the East End through its day-and-night ethos, open-air dining, and Mediterranean-inspired menu. As the culinary jewel of the EHP Resort & Marina, Sí Sí is a celebration providing guests with an elevated dining experience set on the shore of Three Mile Harbor. Their signature paella is a true showstopper, but the lobster cobb salad is as vibrant as the vibe itself and truly photo worthy. Whether you arrive by land or sea, Sí Sí is the place to be for lunch, the sunset, or a late-night supper club scene.

Boat-up restaurant

GOLDBERG'S

Is there anything better than a New York City bagel? Yes, a Goldberg's bagel by the beach. Whether you're in the mood for a BEC, everything with scallion "cc," or a bagel loaded with the best lox in town, you'll be a happy camper coming out of any Goldberg's out east. The Goldberg family's roots grew from flour, water, and yeast as they established the business in 1949. Today, the blockbuster bagel stop is four generations strong, and its famous blue-and-white-logoed shops are sprinkled across the East End like its famous everything bagel seasoning.

COMMON KNOWLEDGE:
Long Island's best bagel

DITCH WITCH

The Ditch Witch is a symbol of summer's arrival to the Montauk community. For over thirty years, the famous family-run food truck has served local surfers, regular beachgoers, and out-of-towners alike. Ditch Witch parked ahead of the food truck curve to offer healthy, convenient, locally sourced food options for Montauk's surf mecca, Ditch Plains. Over the years, the menu has evolved to feature delicious poke bowls (our favorite is the Classic) and sesame noodles (a bestseller since 1994!), and the truck even offers an extensive breakfast menu including Goldberg's bagels (shoutout to another fan favorite) and super yummy chia bowls.

HOOKED

If you make it all the way to Montauk and don't stop for a lobster roll en route, you're in luck with this local to-go seafood eatery. Hooked stands by its mantra: "pure and simple." Here you can order at the indoor counter, then grab a seat outside or take your locally sourced fare on the move for a walk about town. It's true what the owners say: one bite and we were hooked!

LEFT HAND

As self-proclaimed coffee connoisseurs, both Lainey and I are constantly in search of the perfect cup. When Left Hand came to town, we were immediately happy customers. Aside from the perfectly brewed beans, Left Hand also offers Montaukers a wide range of healthy snacks, kombucha, and the comfiest swag coming off the Napeague stretch.

LIFE'S A BEACH

The heart of East End magic is its beaches. From Southampton to The End, we'll take you on a mini tour *from above* to get a bird's-eye view of our favorite spots to soak up the salt, sand, and surf. We decided to let a lot of these beaches speak for themselves through Lainey's lens, but if you need help locating them, you can find additional information in our directory (page 256). From quintessential Hamptons hotspots to smaller beaches off the beaten path, we have a spot under our umbrella for everyone. At the end of the day, there is no beach like home.

Coopers Beach

Ditch Plains

Towd Point

Flying Point

Dune Road

White Sands

Scott Cameron

Napeague Beach

Long Beach

Main Beach

Often rated among the Top Ten Beaches in America, Coopers Beach in Southampton is a standout. Visitors can enjoy its soft sandy shores and coastal breeze while taking a lazy beach walk to admire the glamorous Hamptons mansions.

COOPERS

BEACH

DITCH PLAINS

For decades the waves of Ditch Plains have made this beach the surf mecca of Montauk. We love it not only for the beautiful swells but also for the community it brings to its beach. From surfers and surf casters to sunbathers and sea lovers, a broad range of local and seasonal visitors are attracted to Ditch Plains. Whether you know how to catch a wave or not, there is a reason for everyone to appreciate the beauty of this incredible beach.

TOWD POINT

FLYING POINT

DUNE ROAD

Dune Road is home to several beaches and businesses that we love to visit in Westhampton and Quogue. The 14-mile stretch runs from Cupsogue Beach to Shinnecock County Park West and is studded with beautiful ocean beaches like Pikes, Ponquogue, Rogers, and Quogue Beach.

You'll also find gorgeous homes and awesome eateries along the way. John Scott's Surf Shack and Dockers Waterside Marina & Restaurant are personal favorites for many reasons, and both are memorable in different ways. Speaking of memories . . . we used to head to Dune Road just to dance till sunrise at The Drift (RIP). While its doors have been closed for years, it deserves an honorary mention for anyone else who danced on those decks. Luckily, there are other ways to break a sweat in this neck of the woods.

Dune Road remains a big attraction for runners, cyclists, and water sport enthusiasts. You can even rent a kayak or paddleboard from the marina at Dockers to enjoy the views from the water. You can make a day or a summer out of discovering Dune Road.

WHITE SANDS

SCOTT CAMERON

NAPEAGUE BEACH

LONG BEACH

"

I think having land and not ruining it is the most beautiful art that anybody could ever want to own.

"

ANDY WARHOL

MAIN BEACH

ABOUT *the* AUTHORS

Lainey Stewart—founder, Ten Anchors
(photographer, designer & coauthor)

Lainey is a Long Island–based founder, artist, photographer, creative director, and mom. Her passion for capturing land and seascapes is reflected in her coastal-inspired work. In 2019, Lainey launched Ten Anchors to share her content with a broader audience.

Kaeley Michaelson—cofounder, Ten Anchors
(copywriter & coauthor)

Based in Brooklyn, Kaeley is a cofounder and mom with nearly twenty years of experience in corporate business development, technology sales, and client service. A proud contributor to Ten Anchors, she focuses mainly on storytelling in *Out East from Above*. She splits her time between Brooklyn, the North Fork, and Amagansett with her husband and their children.

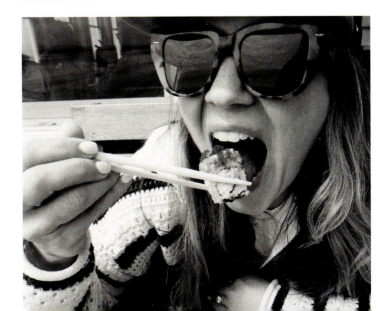

DIRECTORY

SECTION 1—STAY AWHILE

Hero Beach Club
626 Montauk Highway
Montauk, NY 11954

Windward Shores
2062 Montauk Highway
Amagansett, NY 11930

Marram
21 Oceanview Terrace
Montauk, NY 11954

Baron's Cove
31 West Water Street
Sag Harbor, NY 11963

Gurney's (Gurney's Montauk
Resort & Seawater Spa)
290 Old Montauk Highway
Montauk, NY 11954

Solé East
90 Second House Road
Montauk, NY 11954

The Crow's Nest
4 Old West Lake Drive
Montauk, NY 11954

SECTION 2—GET LOST

The Art Barge
110 Napeague Meadow Road
Amagansett, NY 11930

The D'Amico House
(affiliated with the Art Barge)
128 Shore Road Lazy Point
Amagansett, NY 11930

Shadmoor Cliff Walk
900 Montauk Highway
Montauk, NY 11954

Montauk Point Lighthouse
2000 Montauk Highway
Montauk, NY 11954

Peconic Water Sports
215 Three Mile Harbor–Hog Creek
Road, East Hampton, NY 11937

Gosman's Dock
500 West Lake Drive
Montauk, NY 11954

Wölffer Estate Vineyard & Tasting
Room
139 Sagg Road
Sagaponack, NY 11962

Wölffer Estate Wine Stand & Boutique
3312 Montauk Highway
Sagaponack, NY 11962

Wölffer Estate Stables
41 Narrow Lane East
Sagaponack, NY 11962

Sag Harbor Florist
3 Bay Street B
Sag Harbor, NY 11963

Puff & Putt
659 Montauk Highway
Montauk, NY 11954

Montauk Downs State Park Golf
Course
50 South Fairview Avenue
Montauk, NY 11954

Montauk Skatepark
101 South Essex Street
Montauk, NY 11954

The Walking Dunes
At the end of Napeague Harbor Road

Amber Waves Farm
367 Main Street
Amagansett, NY 11930

Montauk Brewing Company
62 South Erie Avenue
Montauk, NY 11954

SECTION 3—QUALITY EATS

The Crow's Nest
4 Old West Lake Drive
Montauk, NY 11954

Duryea's Montauk
65 Tuthill Road
Montauk, NY 11954

Inlet Seafood
541 East Lake Drive
Montauk, NY 11954

Mavericks
51 South Edgemere Street
Montauk, NY 11954

Alimentari Beach
752 Montauk Highway
Montauk, NY 11954

Clam Bar
2025 Montauk Highway
Amagansett, NY 11930

El Taco Bar
62 Main Street
Sag Harbor, NY 11963

Montauk Bake Shoppe
29 The Plaza A
Montauk, NY 11954

K Pasa
2 Main Street
Sag Harbor, NY 11963

Sí Sí
295 Three Mile Harbor Hog Creek
East Hampton, NY 11937

Goldberg's Bagel
28 South Etna Avenue
Montauk, NY 11954
(several locations on the South
Fork and beyond!)

Ditch Witch
Ditch Plains Beach 2nd Parking Lot
(end of Otis Road)
Montauk, NY 11954

Hooked
34 South Etna Avenue
Montauk, NY 11954

Left Hand Coffee
83 South Elmwood Avenue
Montauk, NY 11954

SECTION 4—LIFE'S A BEACH

Coopers Beach
268 Meadow Lane
Southampton, NY 11968

Ditch Plains
18 Ditch Plains Road
Montauk, NY 11954

Towd Point
North Sea, NY 11968

Flying Point
1055 Flying Point Road
Southampton, NY 11968

Dune Road
*Multiple locations and beaches on Dune
Road; here are those we mentioned:*

*Cupsogue Beach
975 Dune Road
Westhampton Beach, NY 11978*

*Shinnecock County Park West
342 East Montauk Highway
Hampton Bays, NY 11946*

*Pikes Beach
765 Dune Road
Westhampton Beach, NY 11978*

*Ponquogue Beach
280 Dune Road
Hampton Bays, NY 11946*

*Rogers Beach
101–105 Dune Road
Westhampton Beach, NY 11978*

*Quogue Beach
172 Dune Road
Quogue, NY 11959*

*John Scott's Surf Shack
540 Dune Road
Westhampton Beach, NY 11978*

*Dockers Waterside Marina &
Restaurant
94 Dune Road
East Quogue, NY 11942*

Long Beach
1000 Noyack-Long Beach Road
Sag Harbor, NY 11963

White Sands
28 Shore Road
Amagansett, NY 11930

Scott Cameron
425 Dune Road
Bridgehampton, NY 11932

Main Beach
104 Ocean Avenue
East Hampton, NY 11937

Napeague Beach
Off Shore Road
Amagansett, NY 11930